Dogs of the Iditarod

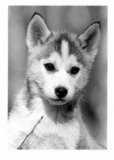

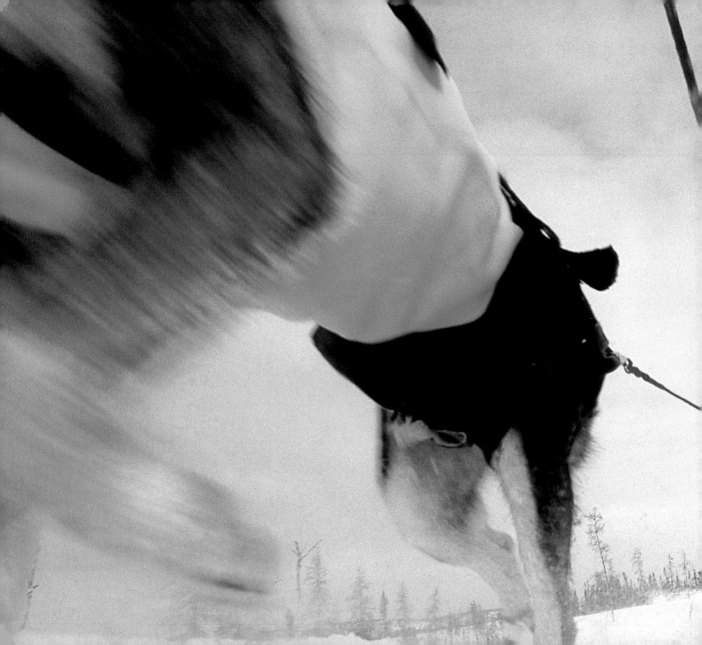

Dogs
of the Iditarod

Jeff Schultz

SASQUATCH
BOOKS
SEATTLE

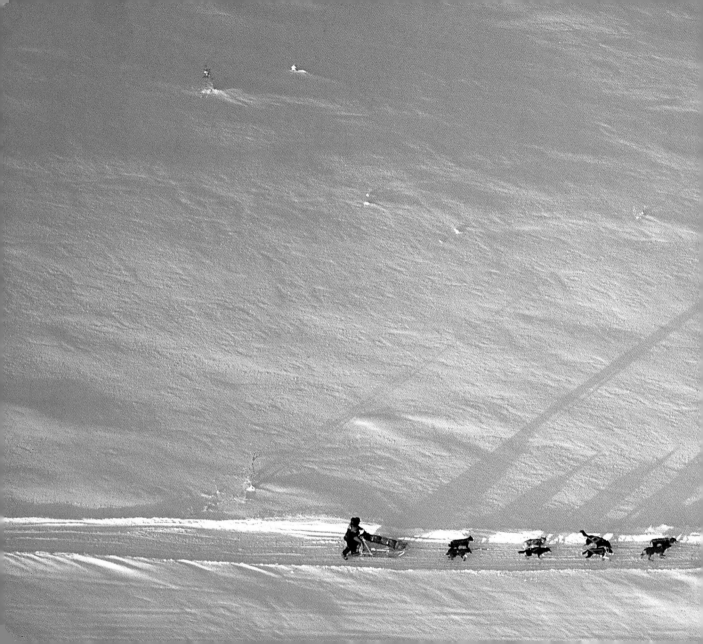

✳

Iditarod. It's a strange name, but it's now known around the world as both a commemoration of a simpler, more rugged yet romantic time as well as the ultimate test of humans and animals against the wilderness. Until 1973, the name "Iditarod" was like its namesake gold-rush town in the middle of Alaska: a ghost, unknown except to only a few. Now, more than thirty years after Joe Redington Sr.'s dream of a sled-dog race across Alaska became a reality, the name has become part of the vocabulary of people the world over. Iditarod is synonymous with grand adventure as well as the traditional ways

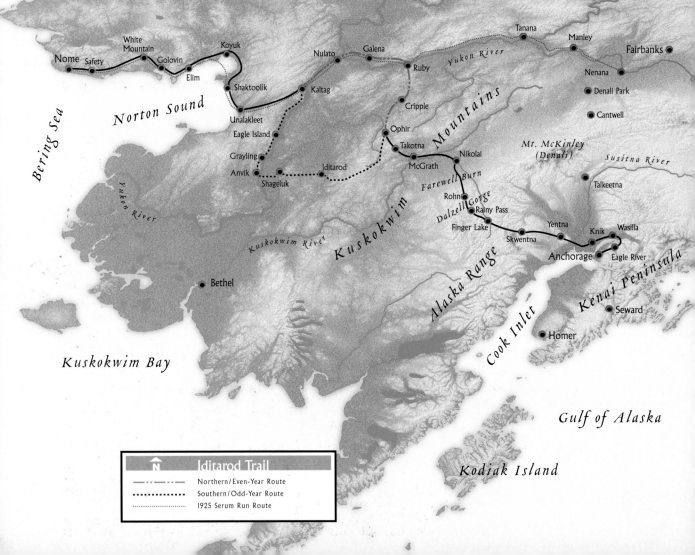

ALASKA

Fairbanks

Manley

Tanana

Nenana

Denali Park

Cantwell

Nulato

Galena

Ruby

Yukon River

Koyuk

White
Mountain

Golovin

Nome

Safety

Elim

Shaktoolik

Kaltag

Cripple

*Mt. McKinley
(Denali)*

Unalakleet

Ophir

Takotna

Susitna River

Norton Sound

Eagle Island

McGrath

Nikolai

Talkeetna

Bering Sea

Grayling

Iditarod

Farewell Burn

Rohn

Anvik

Shageluk

Dalzell Gorge

Rainy Pass

Wasilla

Yukon River

Finger Lake

Yentna

Knik

Skwentna

Eagle River

Anchorage

Kuskokwim River

Kuskokwim Mountains

Alaska Range

Cook Inlet

Kenai Peninsula

Bethel

Seward

Homer

Kuskokwim Bay

Gulf of Alaska

Kodiak Island

Ⓝ Iditarod Trail

— ·· — ·· — Northern/Even-Year Route

• • • • • • • Southern/Odd-Year Route

· · · · · · · 1925 Serum Run Route

of old: people and animals working together in harmony in the grandeur of the Alaskan wilderness. The Iditarod is more than a race. Ask anyone involved and they will tell you it is a very special event that unites the entire state of Alaska for two weeks beginning the first Saturday of each March. And at the same time, it fascinates many the world over.

Right: *Dog handlers keep Danny Seavey's team under control at the restart in Wasilla. Each team is required to have handlers to control the dogs until the team's starting time. The power of these animals and their will to run are unbelievable.*

As thrilling as the Iditarod race is because of its length, history, the terrain it covers, and its unique nature, it holds the attention of a worldwide audience primarily because it involves man's best friend. The dogs of the Iditarod are truly what make this race so captivating. After all, these creatures, with their individual personalities, love of attention, and desire to please, are the heroes, the true athletes of the Iditarod. As important, skilled, and ultimately necessary as the mushers are, they are simply the teams' coaches. Just ask any musher. They'll all tell you that it's about the dogs.

Four-time Iditarod champion and professional dog musher Susan Butcher speaks from her heart: "While most everyone has pets, these dogs are my workmates, friends, and family. I'm there when they are born and there when they die. If I succeed, it is because of them, and yet they are completely dependent on me. Until my marriage and having children, I'd never had a relationship with the intensity of bonding as I've had with my dogs during the Iditarod. There wasn't a year when I wasn't blown away by their capabilities and desire to go, even after a thousand miles."

Part-time musher and Iditarod veteran Judy Currier echoes Susan's sentiments when she talks about the relationship she and her husband, Devan, have with their dogs: "These dogs are really our best

Right: *Straining at the tug lines, these Alaskan huskies watch their musher intently, eager to be running again. Their piercing blue eyes are said to show their Siberian husky lineage.*

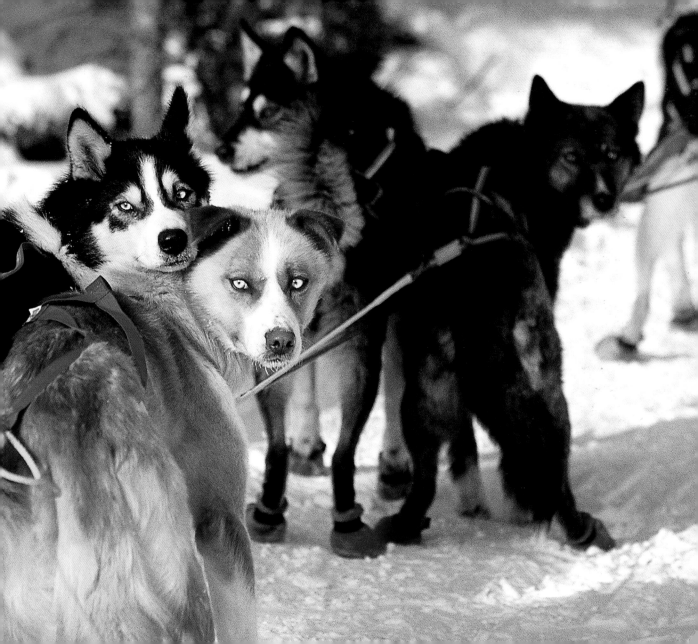

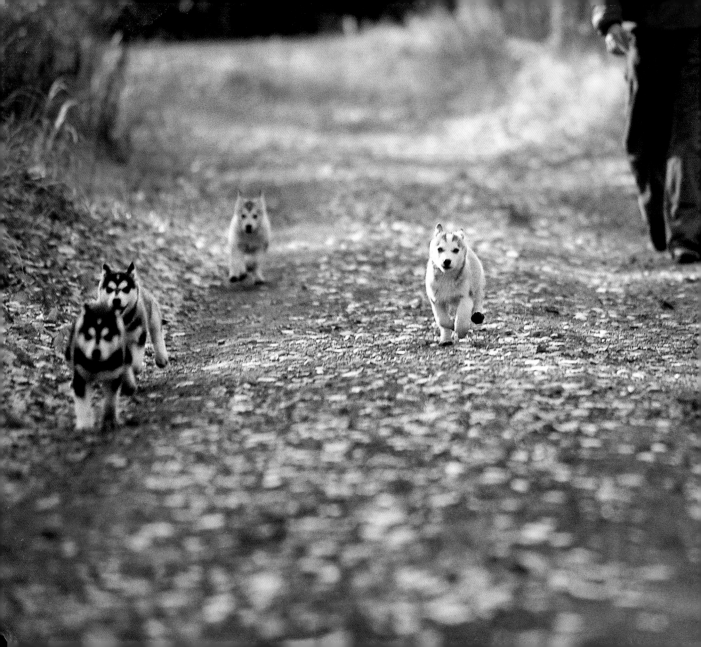

friends. We spend more time with them than we do with family, friends, or even each other." This feeling is voiced by nearly every musher, full- or part-time, who spoke with me. The special bond mushers have with their dogs can't be explained to a non–dog person. Mushers love their dogs the way parents love their children. I've been in the dog yard of many top mushers and, man or woman, they typically call out to their dogs in baby talk, as a parent would talk to a newborn. Mushers will take their special dogs off their leads or out of their harnesses and let them run free, even into the mushers' homes.

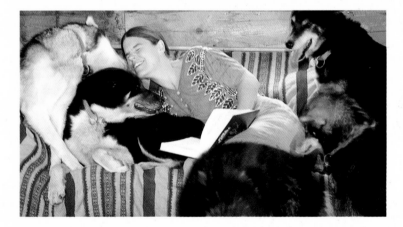

Left: *A litter of seven-week-old pure-bred Siberian huskies take a "puppy walk" with their owner, Judy Currier. These impromptu outings help the young ones socialize with one another and get accustomed to running over uneven terrain.*

Above: *Susan Butcher takes a break from reading to enjoy the company of a few of her huskies. Many dog mushers say this special attention builds the dog's self-esteem and makes for a close bond between the canine and human.*

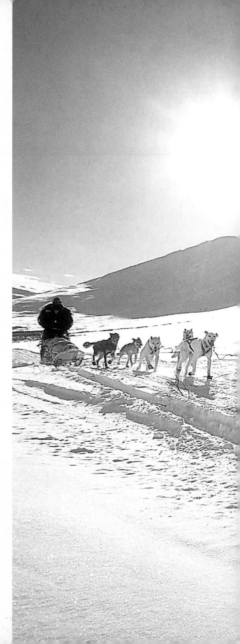

❋

Dogs have been used as an integral part of life in the North Country for a long, long time, a dearth of physical evidence notwithstanding. Archaeological digs in Alaska have revealed parts of dogsleds that are more than 300 years old, confirming the early use of working canines to pull sleds. When the first white men arrived in Alaska from Russia, in the 1700s, dogs were already part of Native life. And of course, by the time of the great Alaska gold rushes of 1897 and '98, dogs were not only common but a necessity in the harsh Arctic climate.

During the gold rushes, enterprising outfitters shipped thousands of dogs to Alaska by boat, to sell as working dogs. Mostly big dogs, such as German shepherds, Saint Bernards, Samoyeds, and large mongrels, were shipped north. In the summer, miners used these dogs as pack animals, strapping their belongings onto the dogs' backs. Dogs also were hitched to various types of vehicles such as small wagons, wheeled carts pulled on train tracks, buggies, and even boats, which they towed upstream on rivers. In winter they were hooked to small sleds to haul firewood and to larger sleds to haul gear and a driver.

Right: *With team dogs Scout and Tomahawk striding near the front, Dan Govani's team crosses the highest point on the Iditarod Trail, 3,160-foot Rainy Pass. Mushers put booties on their dogs' feet to protect the pads from being cut by sharp objects and to keep balls of snow from collecting in the fur between the pads.*

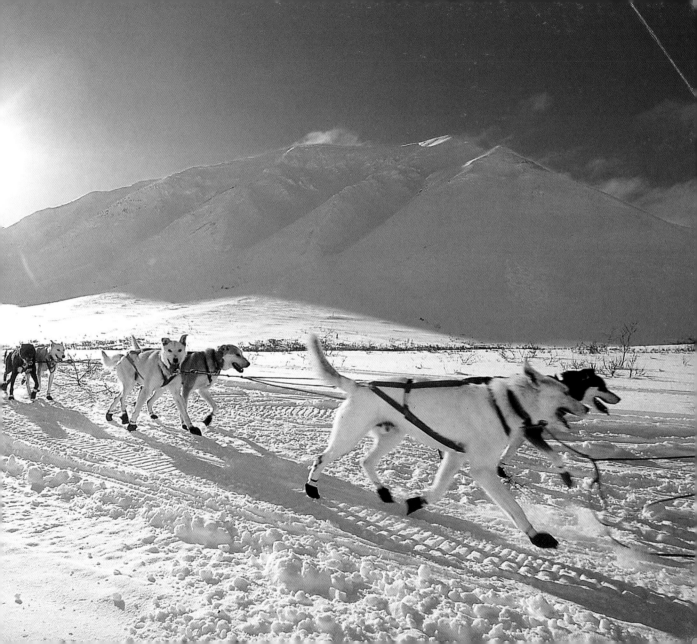

Fur trappers used dogs for running trap lines, while others used them for general transportation and eventually for carrying mail. In the early 1900s, the U.S. mail contracts in Alaska were awarded to the best dog mushers, who would relay the mail along various routes to villages and towns throughout the state.

Of course, with so many dogs around, it was just a matter of time before someone voiced the opinion that his dog team was faster than anyone else's. Although there must certainly have been earlier races, the first organized sled-dog race of record in Alaska was in 1908 in Nome, held by the Nome Kennel Club. These races were not run by professional dog mushers but simply by people who had good dog teams.

✳

As more races were established—with cash and trophy prizes to be won—breeding faster, better sled dogs became a quest. Mushers believed both the Siberian husky—which was thought to be one of the best sled dogs—and the typical "village dog" could be made faster by crossing them with swift breeds such as the Irish

Left: *Excited to be out on the first fall training run of the season, Skooby-doo (age four, on the left) and Mars (age two), both from Judy and Devan Currier's kennel, scream down the trail.*

setter and English pointer. The search was on to find just the right mix to produce the ultimate sled dog—one with attributes such as endurance, good attitude, toughness, good eating habits, honesty, tough feet, and, of course, more and more speed. German shorthaired pointers were bred for vigor and more speed, the Irish wolfhound for its deep chest and bigger lung capacity. The Border collie was tried for its willingness to please. Running breeds such as Saluki and greyhound were crossed with Siberian huskies, as were other northern dogs, including malamute and McKenzie River husky.

Of course, with this type of crossbreeding, sometimes strange things occurred. Four-time Iditarod champion Martin Buser found this out in the mid-1980s, when he was experimenting with dog breeding. He crossed an Alaskan husky with a German shorthaired pointer, resulting in a dog he named Bruiser. Bruiser was raised as a typical sled dog and ran several Iditarods with Buser. One year during the race, while the team was running up the Blueberry Hills outside of Unalakleet on the way to Shaktoolik, they came across a flock of ptarmigan. "Something must have just clicked in Bruiser," says Buser. "He got the idea that he was really a bird dog, not a sled dog, and he went on point. Of course, the other dogs kept right on running and pulled him off point, but he tried several more times to go

Right: *Jim Lanier's dog Happy wears a yellow coat to help keep warm while resting at the Ruby checkpoint. Lanier is one of several mushers who breed for color. He always uses white dogs, and his kennel is appropriately named "Northern Whites."*

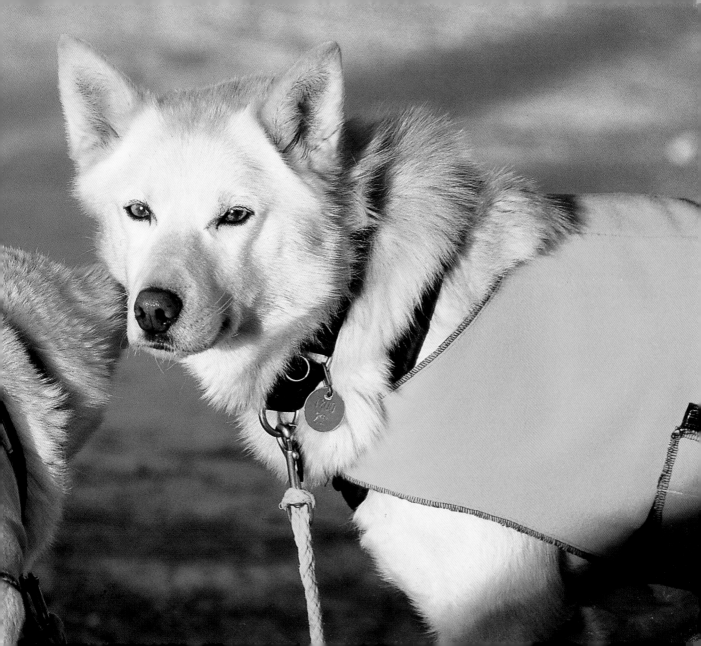

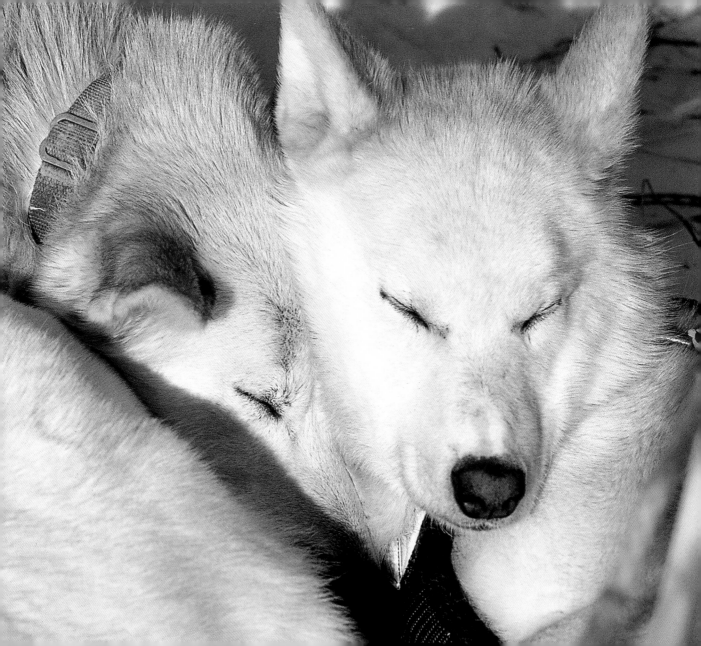

on point, trying to show me where the ptarmigan were. Talk about a multitasking dog."

But good things did come out of all the crossbreeding: faster, tougher dogs; dogs with better feet; dogs with a longer gait; dogs that were swifter and stronger; dogs that had even more energy and stamina. By default, this mixture of dog, with no real pedigree, was called simply a husky, more than likely because the Siberian husky was the main ingredient to this mongrel. Later—and to this day—they were called Alaskan huskies, or Alaskans for short. Martin Buser says that the Alaskan husky is an always-changing mixture of dog that he likes to call a "thoroughbred mongrel," but it still has distinct roots, and any serious musher knows the lineage of his or her dogs.

In addition to the mixed breeds, a few dogs of unusual breeds were trained to be sled dogs. John Suter, a musher from southcentral Alaska, trained full-blooded standard poodles as sled dogs. He ran several poodles in the Iditarod from 1988 through 1991. However, the poodles didn't have a sustained desire to pull, and so John dropped them after '91.

Today's top Iditarod contenders continue to look for what they call the "superdog." This elusive dog has the perfect balance of attributes that are most important: a good head, a good coat, and a

Left: *Two all-white Alaskan husky sled dogs enjoy each other's warmth during a sunny break on the trail.*

good constitution. No one trait is valued more than the others; it's the combination of these three traits that results in a superdog. Each of these traits encompasses several qualities.

A *good head* means the dog has a happy attitude, a desire to travel, willingness to pull, and a love of running and running some more. It also means the dog is "honest." Natalie Norris and her late husband, Earl, both well known in sled-dog circles, have run registered Siberian huskies since the early 1930s. Natalie says a Siberian's honesty, as well as work ethic, is the best. She tells a remarkable story about one of their most honest and loyal lead dogs, an animal they had in the 1960s: Bonzo was one of the few dogs they used as both a sled dog and show dog.

In an Anchorage sprint race, Earl's sled hit a stump when his team was rounding a really sharp turn, and it threw him off the sled. Typically, mushers never let go because a dog team just keeps on going and can get lost or hurt without someone controlling the sled. Besides, it would probably be a long walk home for the musher. However, when Earl's sled jerked abruptly, he simply could not hold on. After several hundred yards, when the lead dog, Bonzo, realized that Earl was not on the sled, the dog stopped the entire team, turned the sled around, and went back to pick up Earl where he'd fallen.

Right: *Dogs who have been dropped from the race wait out a windstorm at the Safety checkpoint. A musher may drop a dog for any number of reasons: if the dog isn't felling well, has an injury, is too young to run the entire race, or is simply too tired to continue.*

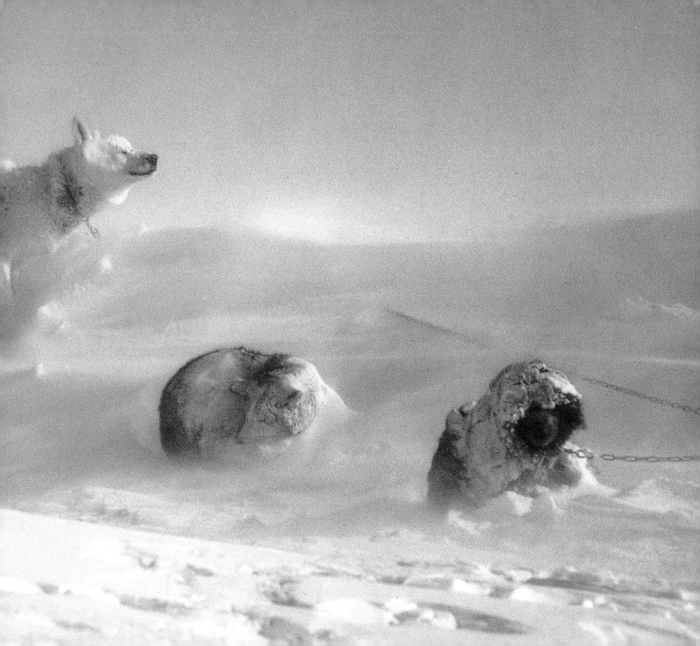

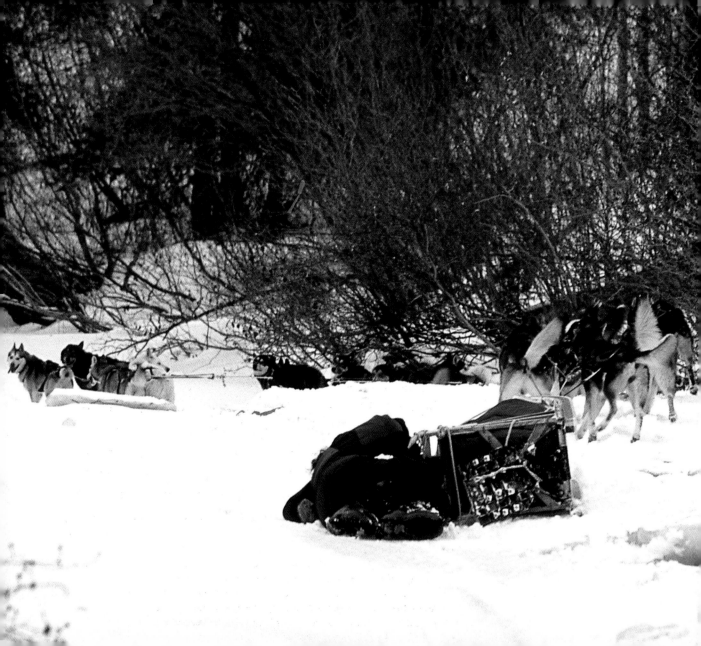

Now that's not only honest, but extremely strong and talented!

This honesty is one of the main traits mushers look for and most likely the reason why the Siberian bloodline is such a staple in the Alaskan husky formula. Later the next summer, when Bonzo had not been on a leash since the previous year, he took first place at the Anchorage obedience school—another testimony of a well-rounded breed of dog. This quality is what Native musher Mike Williams means when he talks about one of his lead dogs, Alta. "I never had a more honest dog. Alta never tried to play a trick on me. She puts her whole heart into pulling and will not attempt to be disloyal."

A *good coat* is another necessary trait for a superdog. A good coat can withstand the cold temperatures and extremes of the harsh Arctic climate. It has guard hairs that can shed water as well as a soft, warm, insulated undercoat. This trait typically comes from the wolf. The first woman to win the Iditarod, Libby Riddles, knows just how important a dog's coat can be. During her 1985 victory run of the Iditarod, she and her dogs were pinned down for twelve hours in a wild wind- and snowstorm on Norton Sound. During a time like that, the dogs curl up with their backs to the wind, placing their tails over their noses to conserve heat. When they get up, they simply shake their bodies and the snow falls off—and they are ready to go.

Left: *Still wanting to move forward, Bob Morgan's team must stop and wait for him to get up and reboard his sled. Bob and his sled tumbled over while negotiating an open crevasse in the Dalzell Gorge during the 1994 race. He followed the number one rule of dog mushing, "Never let go of the sled," and was dragged several feet before the team realized the problem and stopped.*

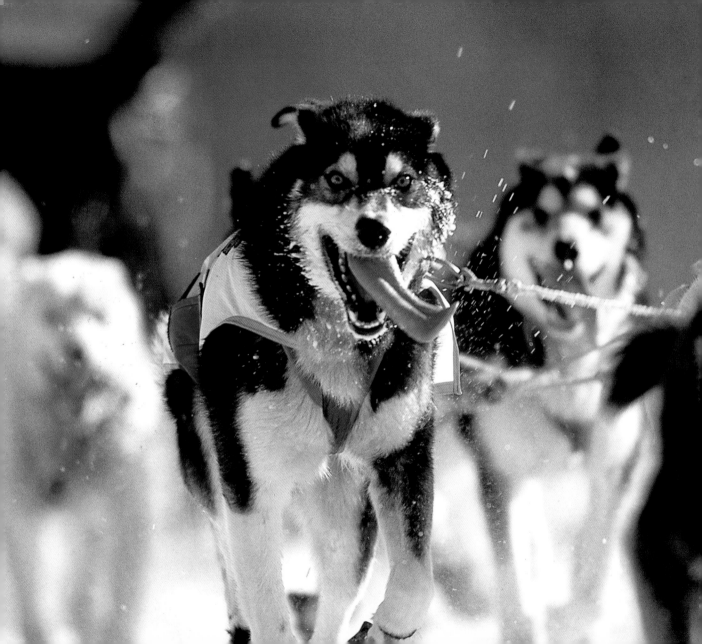

A *good constitution,* the third trait of a superdog, is a combination of several physical characteristics. Martin Buser says, "I look for athleticism in a dog. To me, that means several things. Typically a good, fast dog has a narrow body and runs in a single, narrow track. It also has a deep chest to accommodate the requisite large lung capacity." Although size and weight alone do not determine a sled dog's capabilities, the average superdog weighs around forty-five to fifty-five pounds.

A good constitution also means the dog is a good eater and drinker, one who gobbles down food or water without hesitation. The Iditarod's most-winning musher, five-time champion Rick Swenson, states in his 1987 book *Secrets of Long Distance Training:* "The first and foremost thing, to me, is to have relatively maintenance-free dogs. The number-one and -two criteria for any long-distance sled dog is that it must have good feet and it must be an eager eater and drinker. Good feet don't snowball easily and the pads don't get cut easily." Some dogs are so tough that you can look at their feet at the finish line, and after 1,200 miles they look as good as the day they started.

Left: *A Sonny Lindner dog charges down the trail during the ceremonial start day. Because dogs don't sweat, they need another way to cool down. During times of increased exercise, extra blood flows to the tongue, making it larger than when the dog is at rest. The exchange of warm breath for cool air over the enlarged tongue cools the canine body.*

❄

Although all the dogs in a team are special to a musher,

the lead dog is certainly the most significant. Lead dogs are usually the team's smarter dogs. Being out in front of the team, taking the commands ("gee" for right and "haw" for left), and making decisions during critical times can be stressful for a lead dog. The best lead dogs can usually handle the tough job, but all mushers have more than one leader in the team at any one time so that the leaders can be rotated to reduce the stress.

Deservedly, lead dogs tend to get all the glory. Nearly every musher has a great story about a lead dog that was a hero or simply had an unusually memorable personality. Susan Butcher tells a classic story. In late fall 1986, she was putting in ten-mile runs each day with a team of seven dogs. There was a good bit of snow, and the rivers and streams were pretty well frozen, but not totally solid ice. She was traveling on a trail she had not tried yet that year, on Hutlinana Creek near her home in Eureka. She was out alone, and it was minus ten degrees Fahrenheit. Every so often, the weight of the sled broke through the ice, and she could see and hear the four- to eight-foot-deep water

Right: *Three-year-old Grover gets a ride to the next checkpoint. Grover became tired along the twenty-eight-mile run from Elim to Golovin, so musher Jeff King placed him in the sled for the next eighteen-mile stretch to White Mountain.*

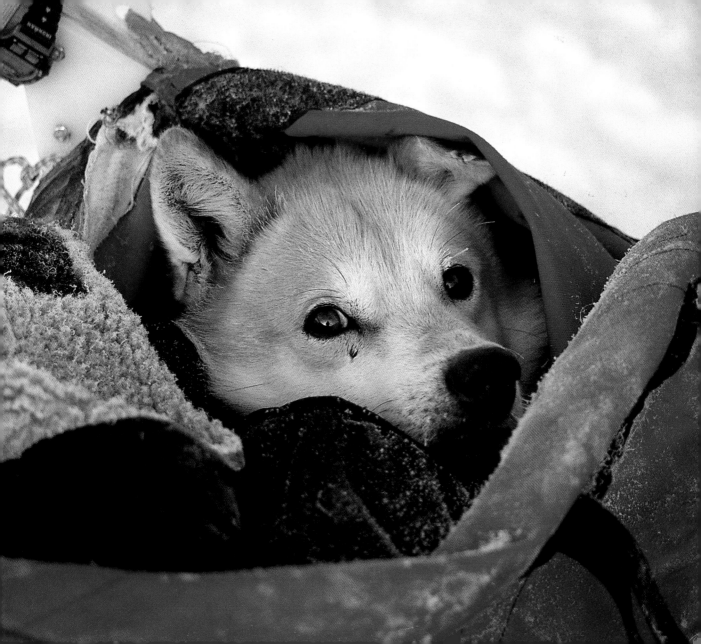

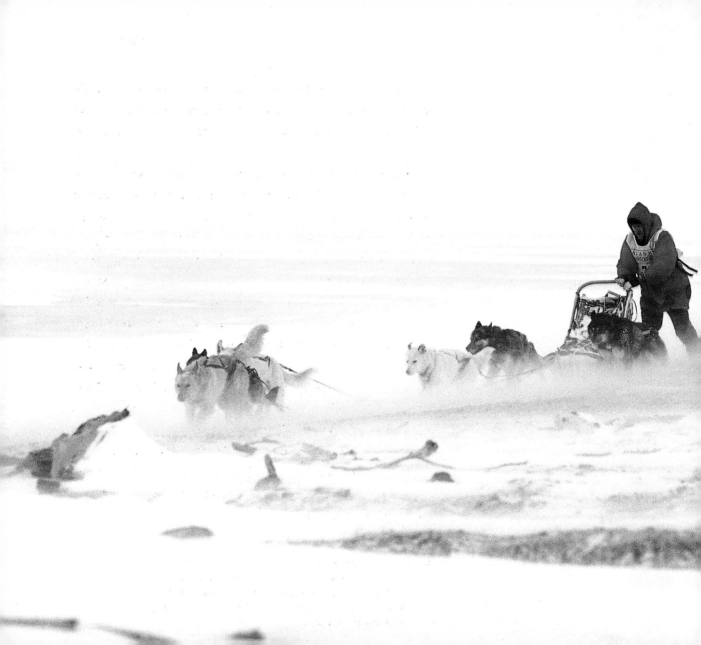

rushing swiftly below. She wanted to get off the creek because the breaking ice was making her quite nervous, but the banks were steep and there were no visible trails where she could easily turn around. So she kept going.

Suddenly she and her dogs came upon a spruce tree hanging low across the water. The dogs went under it, but the sled could not, so Susan jumped off backward to avoid getting hurt. The sled got stuck under the tree. Susan figured this would be as good a place as any to turn the dogs around, climb the bank, and get off the ice. She walked about fifteen feet from the sled, looking for the best way out. With no notice, the ice gave way and she fell, up to her chest, in frigid water. She struggled for a good two minutes trying to get out, to no avail. She thought, "This is it." She knew she couldn't hold on. Susan turned to look at the dogs, which by now were staring at her. She looked into the eyes of her lead dog, Co-Pilot. Without a word from Susan, Co-Pilot and his co-lead dog, Ali, swung the team around, with the sled still wedged under the tree, so that they could reach her. Susan grabbed onto the lead dogs' collars and again without any command from her, the team backed up and pulled her out. Susan got the sled free and quickly mushed back down the creek to home.

Left: *Fourteen miles from their third Iditarod victory, in 1998, Jeff King and his team press on through a ground storm. When the trail is obliterated like this, experienced lead dogs, like King's Red and Jenna here, can smell and sense the trail, particularly if they've been over it before. In times like these, a musher puts all his trust in his dogs to find the way.*

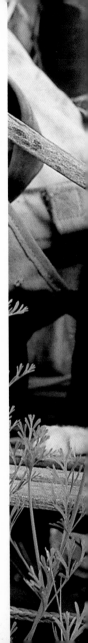

Having experiences such as this, mushers certainly realize just how special their lead dogs are. At the end of the Iditarod each year, the finishing mushers vote on the "Golden Harness" award. This goes to the lead dog that best exemplifies the spirit of lead dogs—honesty, bravery, and stamina.

Lots of stamina training is a basic part of the daily life of a sled dog. After the pups are born, the musher plays with them from the very first or second day in order to get them used to a human and to being handled. Susan Butcher, for example, blows on the pups to make them familiar with her and her scent. The pups are weaned from five to twelve weeks of age, depending on the mother, and are usually put into a large pen with their littermates and other pups of the same age. This socializes the dogs and mushers have fewer "fighters" when they do this. A musher simply cannot tolerate a dog that wants to fight.

Most mushers start taking the pups out at this same age for regular "puppy walks." This allows the dogs out for some fun in the forest

Right: *Eight-week-old Alaskan husky puppies from Lynda Plettner's kennel play in an old, traditional-style dogsled.*

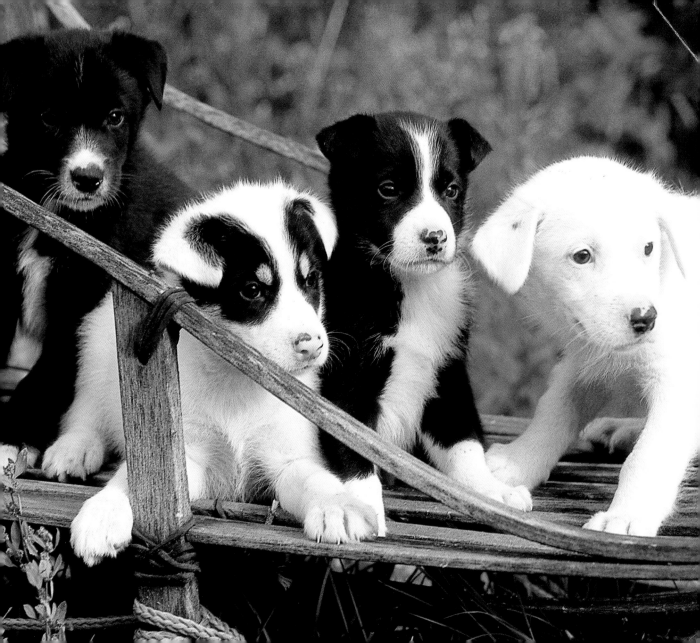

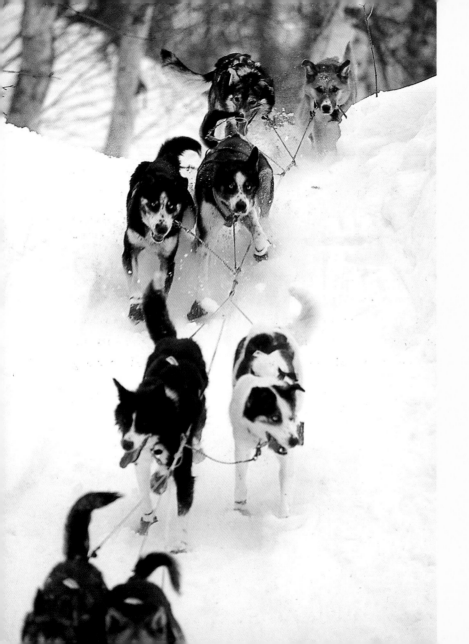

Left: *During the 2000 Iditarod, Alaskan huskies from Ramy Brooks's team charge down a hill on the "Happy River Steps," a stretch of trail with a series of hills and switchbacks notorious for throwing mushers from their sleds.*

and gets them used to running over uneven terrain. A musher usually has an adult dog or two along for the puppy walk as well.

The pups stay in the large pen until they are about four to six months old, when they each get their own doghouse. At six to nine months old, the pups are "harness broken." Mushers harness-break them in several ways. Veteran Iditarod musher and pathologist Dr. Jim Lanier, as well as Judy and Devan Currier, harness the young dogs with an experienced dog and take them for walks along a trail. Others, such as Iditarod veteran Lynda Plettner, simply put the young dogs in a harness and take them for a short run. She wants the first run to be a very fun and pleasant experience for the young pups, so she'll hook them up single file because the frisky pups tend to jump on each other in play, which can lead to tangles if they run side by side. She also makes the team more controllable by hooking

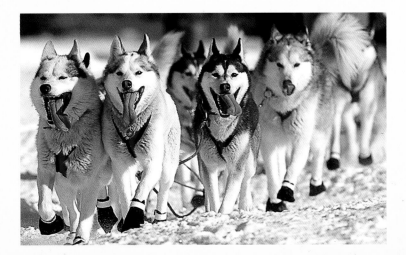

Right: With ears erect and in syncopated rhythm, registered Siberian huskies from Karen Ramstead's 2001 team run down the trail near the Willow restart. Siberians epitomize the "husky look."

up just four or five pups with a few older, slower, retired dogs in the lead positions. Four-time Iditarod champion Doug Swingley also harness-breaks his young dogs in this way. He says, "Within the first hundred yards, they realize they are sled dogs and love it from then on."

A typical day for a sled dog in training is fairly simple. In the early autumn before the first snowfall, they go for short, two- to four-mile runs on the bare ground, pulling a four-wheeler ATV instead of a sled. If the dogs get tired, the musher can easily power up the ATV so the dogs are not pulling so much of its weight. They increase

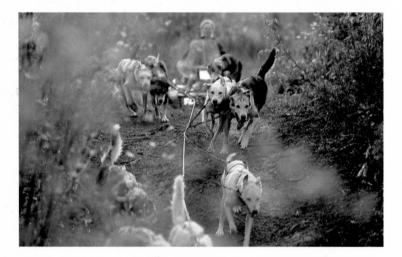

Above: *Lynda Plettner's team pulls her along in her four-wheeler during an autumn training run. Although the gangline (the rope down the middle) is designed so that the dogs will run on either side of it, some dogs have their own methods—in this case, both running on the same side.*

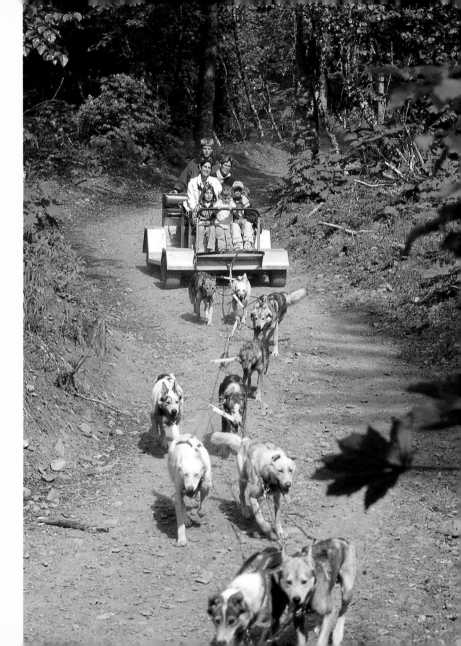

Right: *Alaskan huskies on a demonstration run give a real thrill to summer tourists at Iditarod musher Mitch and Janine Seavey's "IdidaRide Sled Dog Tours" in Seward. Giving the dogs this little extra exercise in the summer keeps them in shape all year, making the racing season training that much easier.*

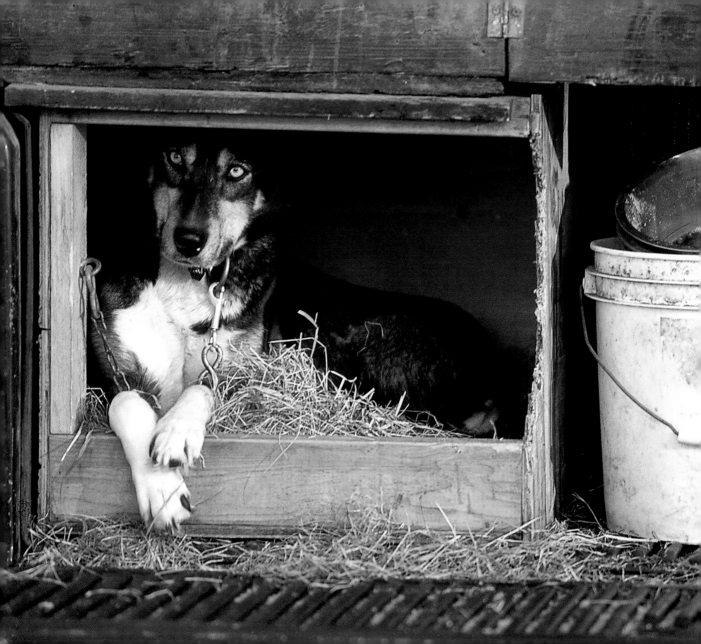

the number of miles as the season progresses, then begin pulling a sled once the snow cover is adequate. Winter training mileages vary from musher to musher, anywhere from ten miles on up to fifty or more.

Jim Lanier tells a story of a wild training run early in the season one year. On a long run, he and his team went by a lodge that had some farm animals. Some geese were next to the trail, and he commanded the team to "go by." It's quite a challenge for dogs not to chase birds, but his well-trained lead dogs did so without a hitch. He was amazed and proud, but only for a split second. Suddenly, the team dogs (those dogs following the leaders), who were not as well trained, jumped off the trail trying to catch the geese, which ran into a chicken coop to escape. Before long, nearly the entire team was inside the chicken coop with a chicken in every dog's mouth. With a few loud, startling shouts from Jim, the dogs immediately dropped the chickens, unharmed. Though it took a couple of minutes to extract the dogs, two by two, through the small opening, Jim was soon on his way, with the lodge owners laughing behind him.

After a training run, the dogs are put up in their individual houses back at the kennel and then watered and fed. They stay there until the next run either later that same day or the next day, depending on the musher's training schedule.

Left: *A sled dog waits patiently in his temporary traveling house inside the bed of the musher's pickup truck at a race start.*

Sled dogs typically run the Iditarod or other races as rookies when they are eighteen months to two years old as part of a slower, noncompetitive team. This gives the young dogs experience, and the musher can see which dogs really want to be a top sled dog and which won't make it. Dogs that don't make the cut are either sold as pets or as sled dogs to others wanting to get into the sport in a non-competitive way. A dog that proves it's a good sled dog will then run in races from the time it's two or three until it's ten or twelve years old. Some dogs have been known to run until age fourteen.

❋

Dogs that spend their entire lives on the team are usually retired by being sold to a good home. The musher might keep very special dogs simply as pets or to train younger dogs. Doug Swingley's most

Left: *Alaskan husky and lead dog Angel sleeps in the sun atop her doghouse at Plettner Kennels. Summer is not nearly as much fun for the dogs as winter because the days are too warm to run. But as autumn approaches, teams are hooked to four-wheeler ATVs for short runs.*

Right: An Alaskan husky from Dave Sawatzky's team waits for the next command, its breath condensed and frozen on its face after a twenty-mile run in below-zero temperatures.

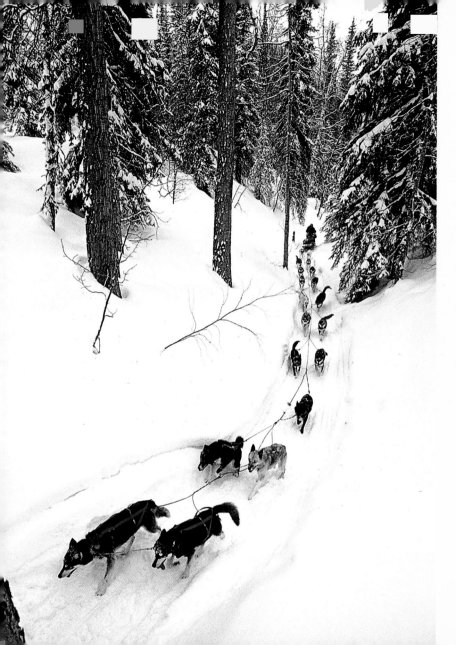

Left: *With nineteen huskies strung out before her, Diana Morony moves through a spruce and birch tree forest on her way from Finger Lake to Rainy Pass. With a team length this size and a trail that winds in and around, a musher often times doesn't see the lead dogs for stretches of time.*

Right: *As usual, the dogs get all the attention from race fans. A regular Iditarod devotee, Bob Hendershott travels with his wife, Connie, from Washington State each year to cheer on the dogs and mushers. Here, Bob holds a sign in Nome to welcome in Raymie Redington's team, the son of the Father of the Iditarod, the late Joe Redington Sr.*

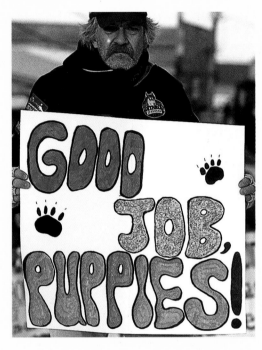

exceptional lead dog, Elmer, retired at age eleven, but he still has his place in the dog yard and continues to help Doug train puppies to be leaders. To train puppies, Doug puts a yearling in the lead next to Elmer. As they go down the trail and Doug gives a command, Elmer performs the command perfectly, which teaches the yearling exactly what it should be doing. Retired dogs also go with mushers to visit schools or nursing homes when the musher is asked to give a talk about mushing and the Iditarod.

Joe Runyan, 1986 Iditarod champion, says, "The sled dog, of which the Alaskan husky is king, is not a breed of dog but, rather, a concept. The concept is 'pull hard and run fast.'" Joe states that "the sled dog is an ever-changing breed, always has been, always will be, and, hands down, the Alaskan husky is the fastest and hardest-working dog alive." Doug Swingley agrees: "The Alaskan husky is the ultimate dog athlete. It's the decathlete of the dog world. The Alaskan husky can run faster, jump higher, and, if it could skip, skip better than any other dog alive. No dog in the world can do what the Alaskan husky can do."

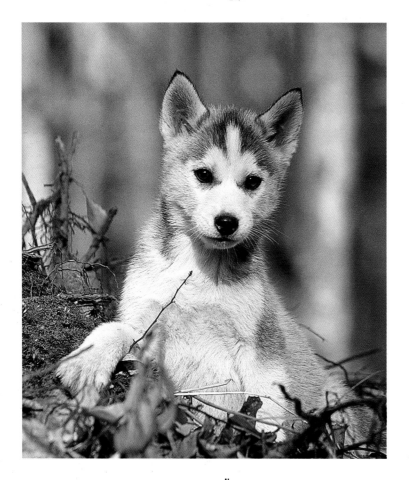

Right: *Two of Doug Swingley's ten-week-old Alaskan huskies play together inside their puppy pen.*

Above: *A seven-week-old Siberian husky on a puppy walk through the autumn tundra of Alaska.*

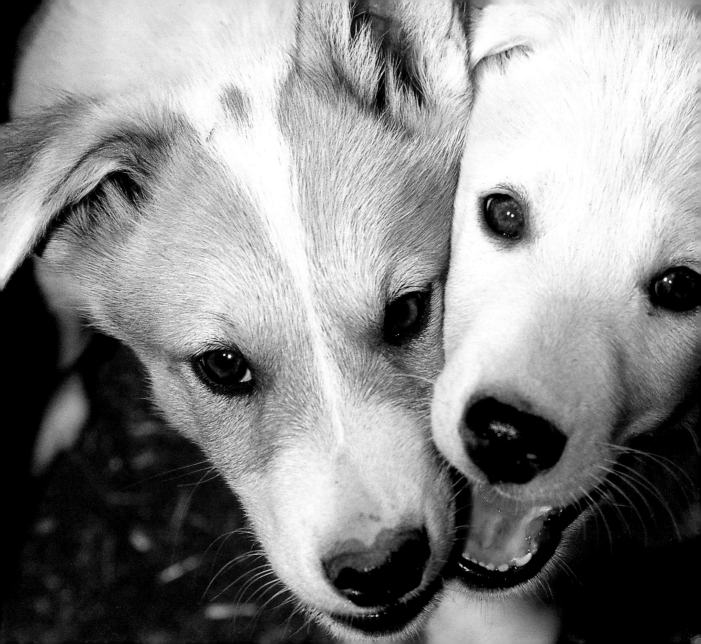

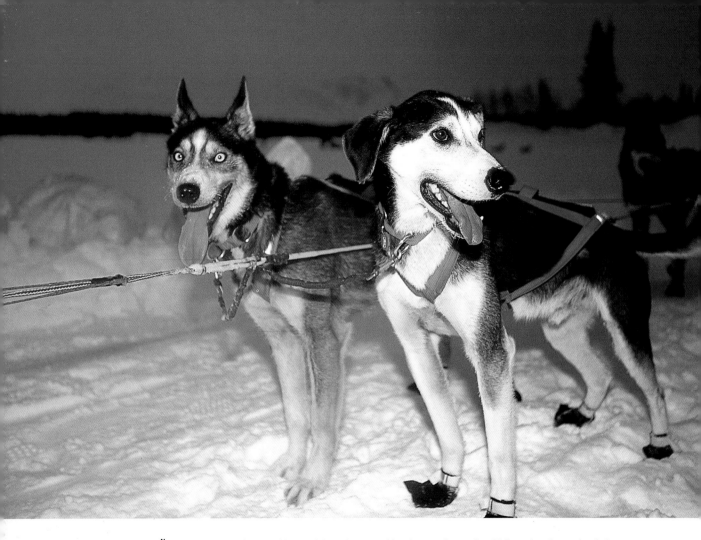

Above: *Rick Swenson's five-year-old Viper (left) and six-year-old Bud are good examples of different breeding in the Alaskan husky. Viper shows typical husky traits such as pointed, erect ears and the blue eyes from the Siberian husky side. Bud has the floppy ears bred in from the English pointer. Also, Bud needs to wear booties because his feet are not as tough as the Alaskan.*

 Right: *A young Alaskan husky in its pen.*

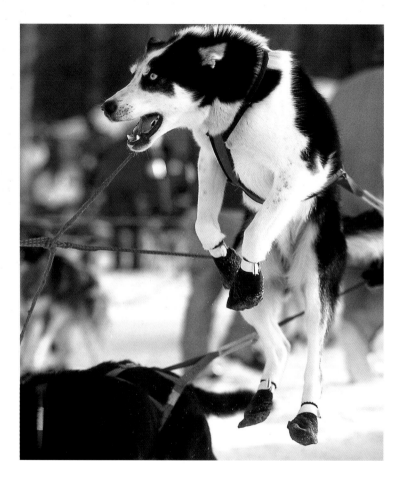

Left: *A Zack Steer dog jumps and barks in its eagerness to get going at the 2000 restart in Wasilla. At the beginning of a race, the dogs are too excited to stand still. This excitement can lead to them "pulling the hook" and leaving without the musher. Because of this, mushers are required to have a group of handlers who hold the dogs back as they are walked to the starting line.*

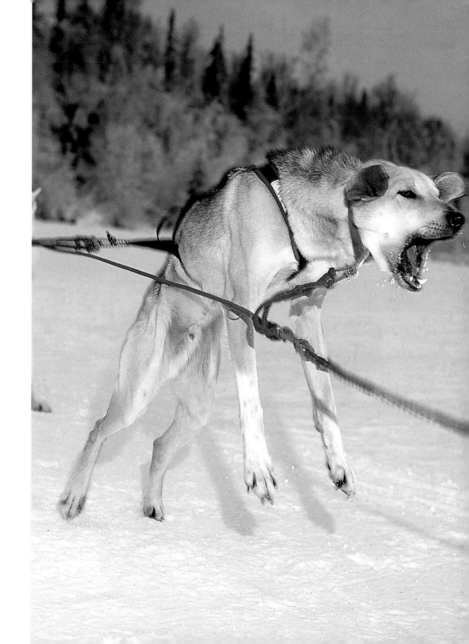

Right: *Woody, an Alaskan husky from recreational mushers Julie and Harold Capps, barks and pulls with all his might to get the sled moving during a run at the Chugiak Dog Musher's trail in southcentral Alaska.*

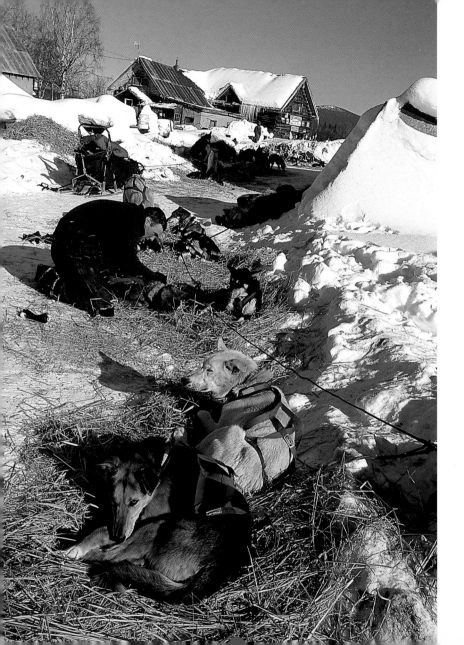

Right: *The dogs get all the attention from these Unalakleet school children, who are let out of school each year to watch the first Iditarod musher arrive at their village. Here, in 2001, it was Doug Swingley's team that garnered all the affection.*

Above: *Rookie musher Lisa Frederic's Alaskan husky Houston rests comfortably in the sled bag shortly after Lisa's arrival at McGrath checkpoint.*

Right: *Veterinarian Caroline Griffitts works with some of Jeff King's dogs during a late-night rest at the Iditarod checkpoint. Each checkpoint is manned by three to five veterinarians who work shifts around the clock. Every dog is examined at each checkpoint, and any abnormalities are recorded in the musher's mandatory "vet book," which must be carried from checkpoint to checkpoint, to ensure that the health and condition of every dog is carefully monitored.*

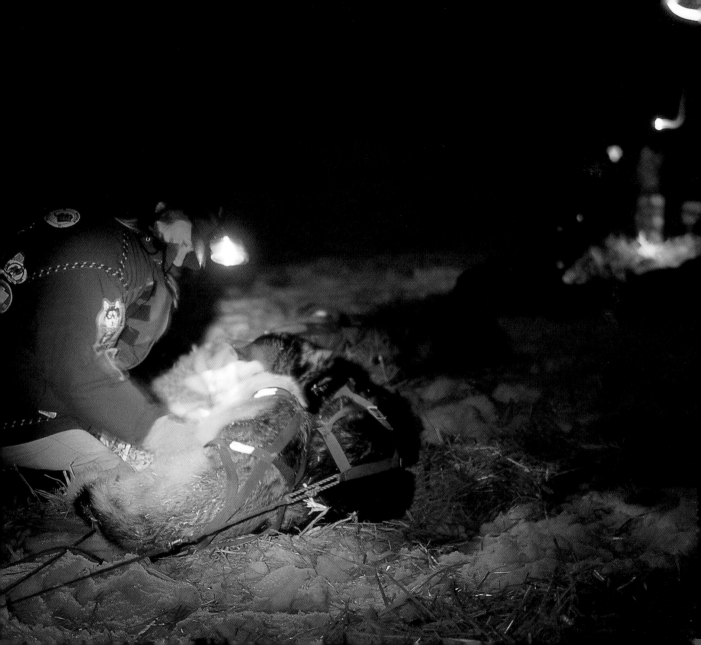

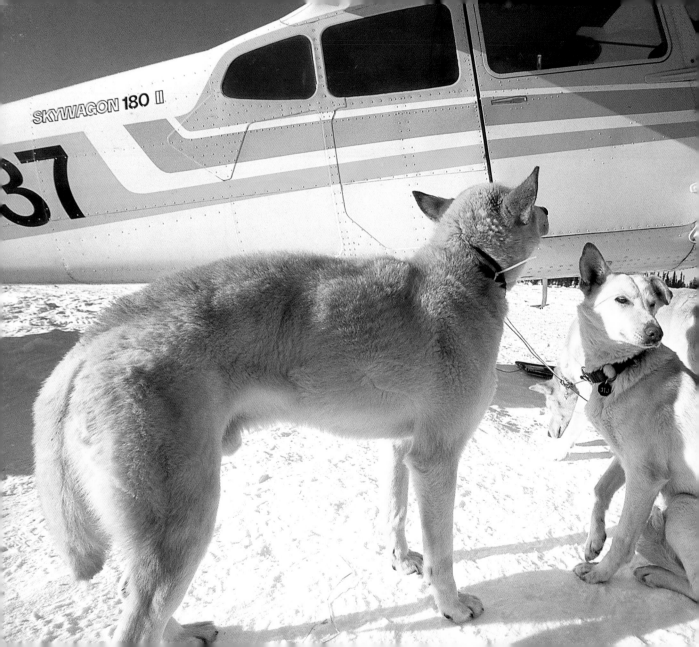

Above: *Dogs who were dropped from the race wait inside a volunteer Iditarod airforce plane to be flown back to their homes.*

Left: *These three dropped dogs are about to be loaded into volunteer pilot Jim Kintz's plane at the Cripple checkpoint during the 2002 Iditarod. The dogs will take a short plane ride to one of the major hubs, where they will be flown aboard a commercial airplane to Anchorage or their home.*

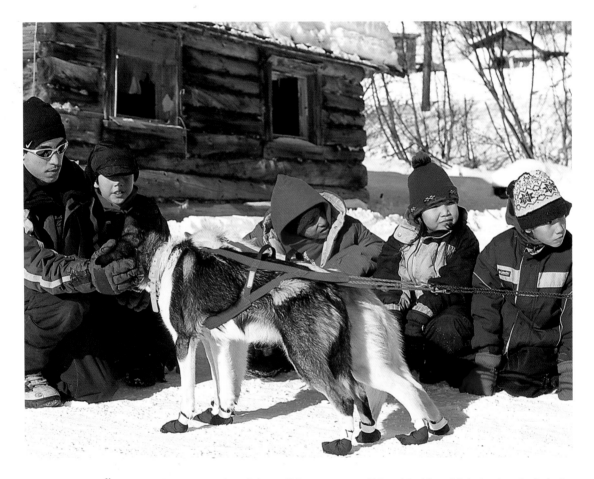

Above: *During the 2002 race, Tokotna kids give all their attention to Bill Cotter's lead dogs while he signs in at the checkpoint.*

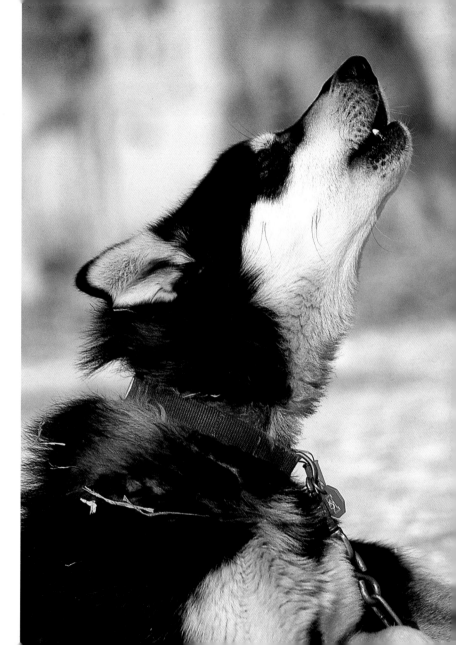

Right: *Its wolf-like howling instinct well ingrained, a husky croons into the winter air at the dog lot in Nome. Often when one howls, all the dogs nearby chime in to become part of the serenading chorus.*

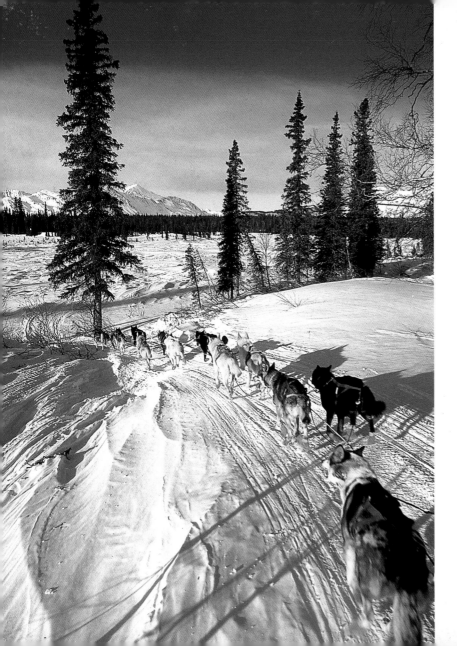

Left: *With the Alaska Range in the background, Linwood Fiedler's team of huskies, all wearing booties for protection, move as a unit down the hard-packed trail near Finger Lake.*

Right: *An Alaskan husky rests his head on his running partner's back during a short stop at the Tokotna checkpoint.*

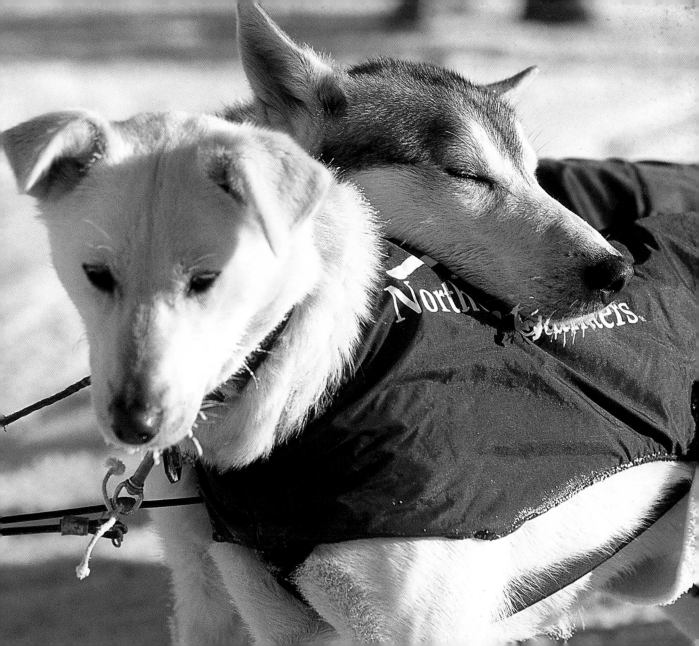

Above: *Four-month-old Oakley eats his lunch atop his new doghouse. Oakley was just recently taken from his pen and given his own quarters. Soon after that, he was put into harness for the first time.*

Right: *With their eyes just recently open, these three-week-old Alaskan husky pups move around cautiously in their strange new world.*

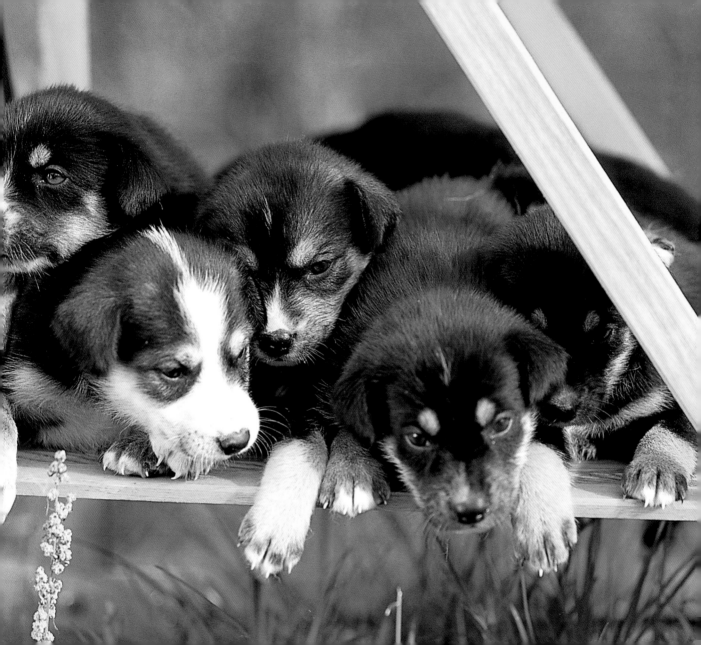

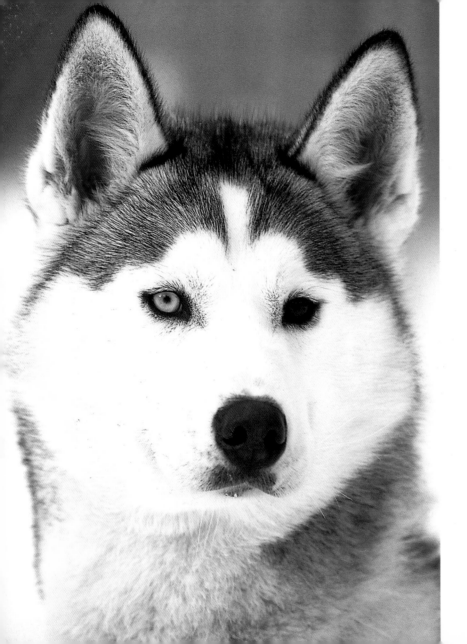

Left: *One-year-old pure-bred Siberian husky Qanikcuk, from Harold and Julie Capps's Dancing Dog Kennels, shows the "bi-eye" trait of one blue and one brown eye. Qanikcuk's father has what's known as "party-eye," with several colors in one eye. ("Qanikcuk" means "snow" in the Alaska Native Inupiat language; it's pronounced Konnikchuk.)*

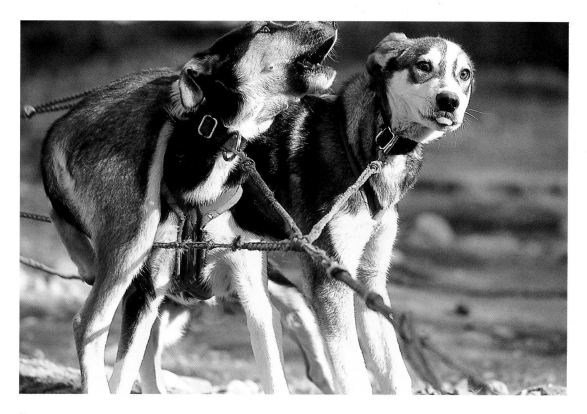

Above: *Whose legs are whose? Their first time in harness, these two youngsters from Lynda Plettner's kennel find out the meaning of the word "tangled."*

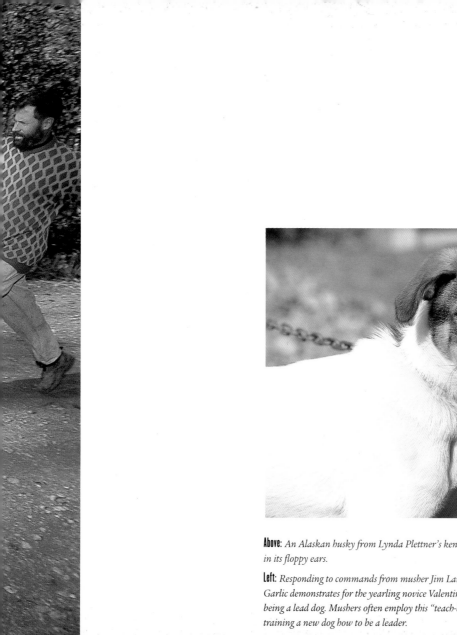

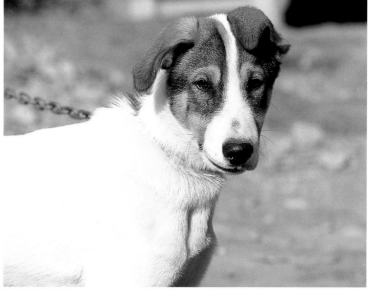

Above: *An Alaskan husky from Lynda Plettner's kennel shows its hound breeding in its floppy ears.*

Left: *Responding to commands from musher Jim Lanier, four-year-old veteran Garlic demonstrates for the yearling novice Valentino the proper techniques of being a lead dog. Mushers often employ this "teach-by-example" method of training a new dog how to be a leader.*

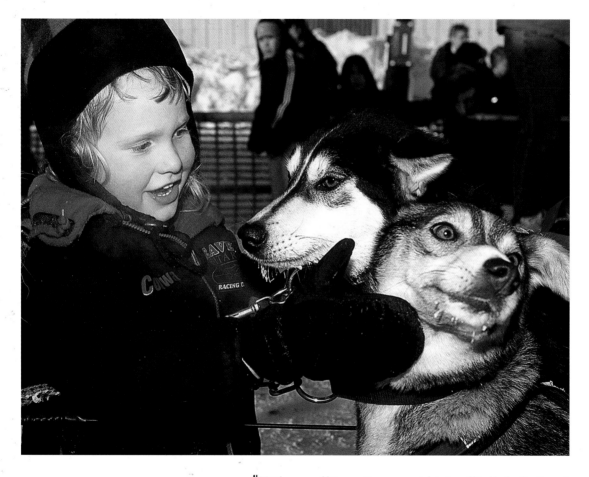

Above: *Three-year-old Conway Seavey congratulates two of his older brother Danny's dogs shortly after they finished the 1,200-mile Iditarod in 2001.*

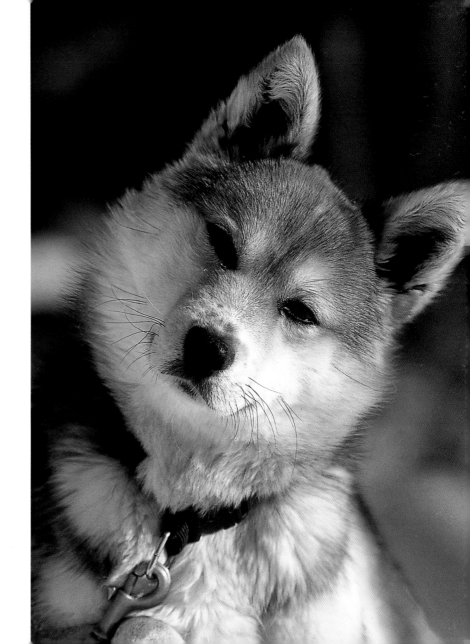

Right: *A Shaktoolik village husky pup gazes inquisitively at other Iditarod dogs at a checkpoint.*

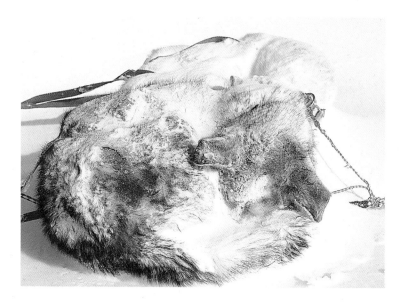

Above: *With his tail curled over his nose, a husky assumes a comfortable position to wait out a windstorm. The combination of guard and under hair insulates the dogs and keeps the windblown snow from getting anywhere near their skin.*

Right: *A registered Siberian from the Earl and Natalie Norris Kennel, who ran in the 2002 Iditarod with Russian musher Nikolai Ettyne, sleeps peacefully in Nome.*

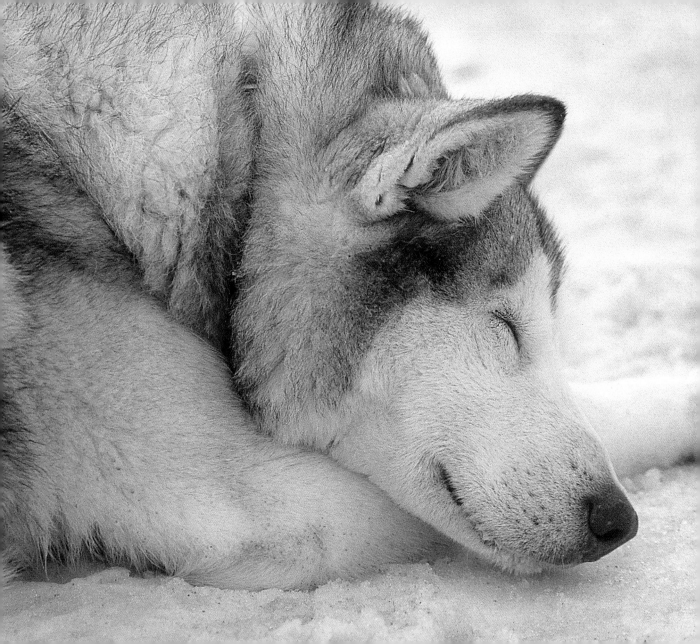

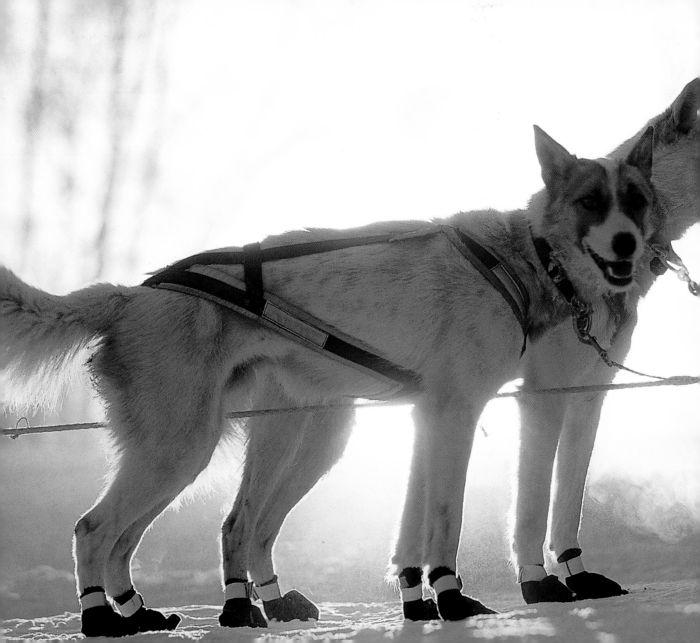

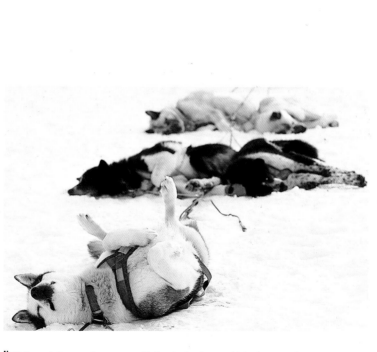

Above: *Sprawled out on the snow, an Alaskan husky sleeps on his back, warmed by the sun.*

Left: *Shawn Sidelinger's dogs Mocha and Maxwell stop at sunrise in Tokotna during the 2000 race.*

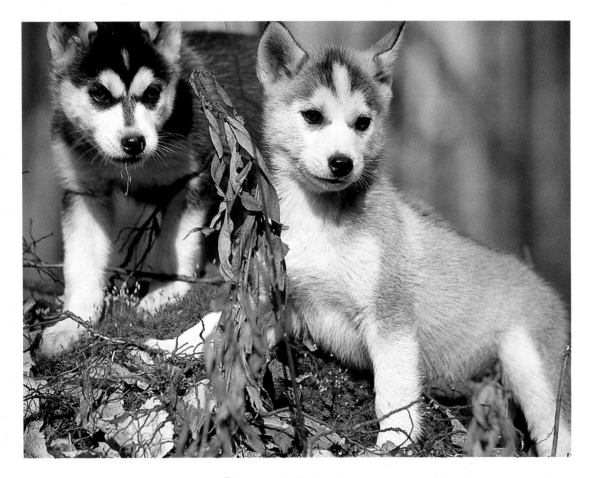

Above: *Seven-week-old Siberian husky pups Gwenevere and Bonsai play in a forest in Alaska.*

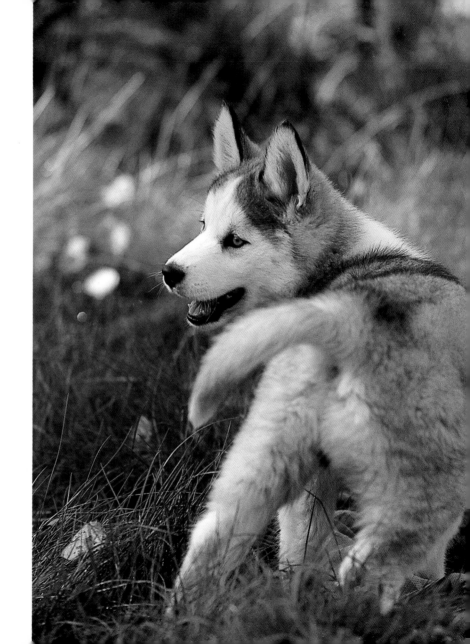

Right: *A pure-bred Siberian pup, Lara-ke's Rivers, strikes a pose for his photo. In Siberian circles, protocol requires the given name of the animal to be preceded directly by the kennel name. In this case, "Lara-ke" is the kennel name of Judy and Devan Currier, while "Rivers" is the dog's actual name.*

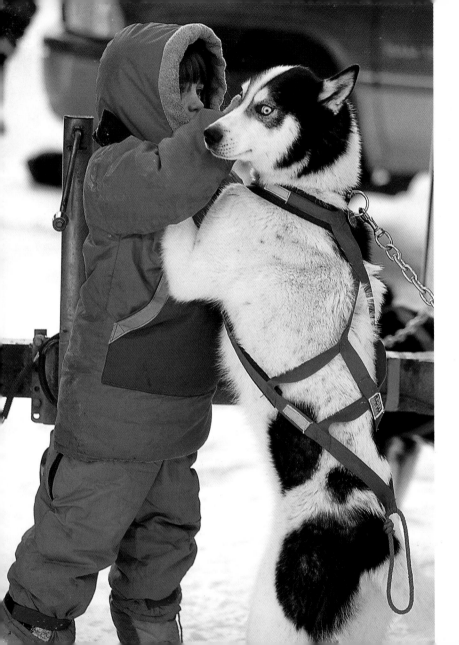

Left: *Neesa, a veteran of two Junior Quest races and two Junior Iditarod races, gets a welcome pet from six-year-old Logan Claus, sister of Junior musher Ellie Claus. Neesa is from the Joe Redington Sr. bloodline, which produced many dogs with this pinto-type coloring.*

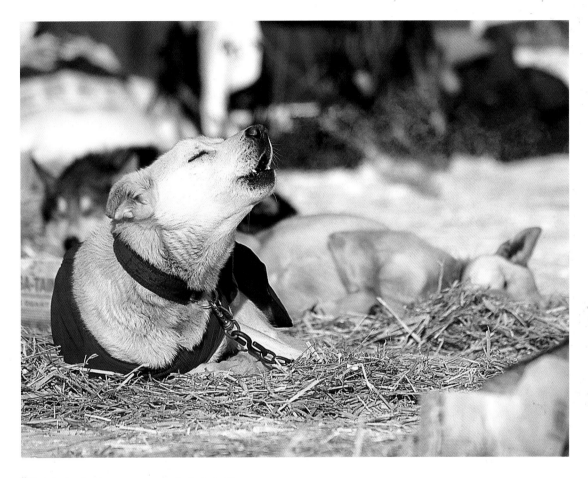

Above: *A dog howls as he rests on straw in the dog lot in Nome.*

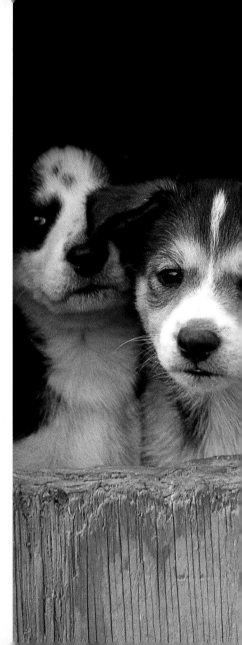

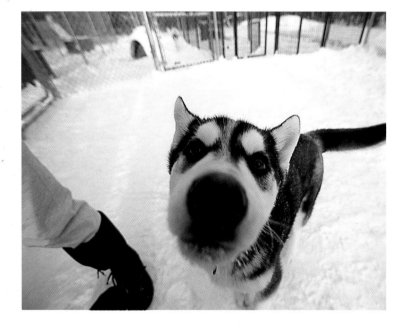

Above: *Snuukuuk, which means "snowmachine" or "snowmobile," in his pen at the Harold and Julie Capps Kennel in Chugiak.*

Right: *Puppies bred from a Susan Butcher dog peer from their doghouse.*

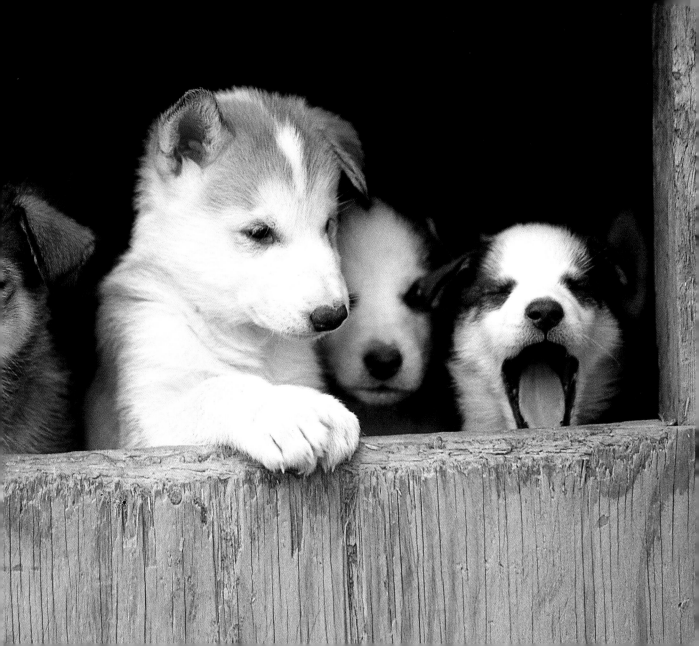

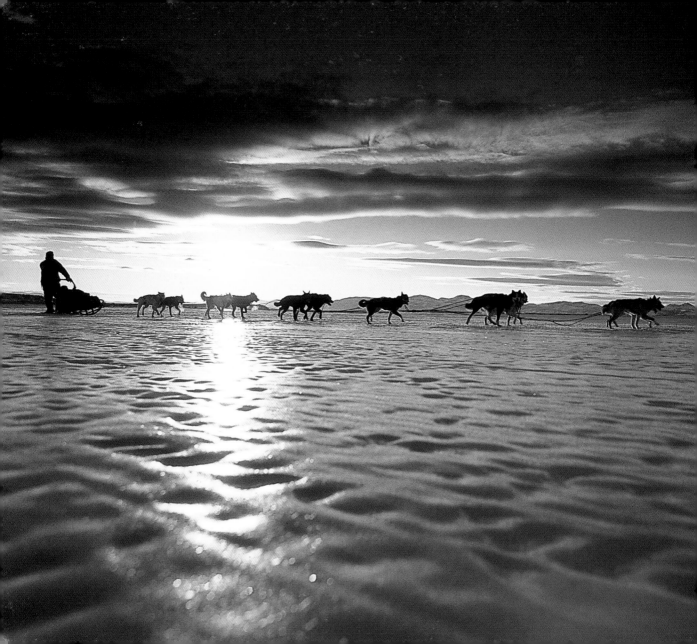

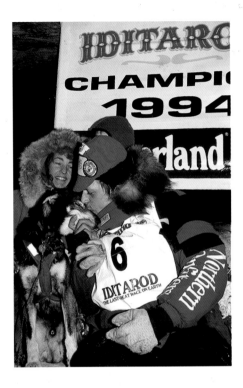

Left: *Linwood Fiedler's team crosses slick ice on the Unalakleet River as the sun rises during the 1998 Iditarod. The dogs are often nervous when crossing such ice because of the slippery conditions.*

Above: *Multiple Iditarod champion Dave gets a congratulatory kiss from Martin Buser on the winners stand in Nome after the team's second victory in 1994. In a traditional ceremony for the winner of the race, the lead dogs are put on a pedestal with the musher and given a garland of roses.*

Acknowledgments

✳

I thank God who by His grace I am able. I want to thank Kate Rogers and all the folks at Sasquatch for offering me the privilege of making this book. A special thanks certainly goes to the fine mushers I contacted for this book who took the time to answer my many questions about their canine friends and, in some cases, allowed me to photograph at their kennel: Dr. Terry Adkins, Martin Buser, Susan Butcher, Harold and Julie Capps, Judy and Devan Currier, Dr. Jim Lanier, Natalie Norris, Lynda Plettner, Libby Riddles, Joe Runyan, John Suter, Rick Swenson, Doug Swingley, Mike Williams, and Roxy Wright. A great big thanks also goes to all the Iditarod mushers and volunteers I've known through the many years I have been involved in the race. They are all good company to be with and the main reason I come back year after year.

—*Jeff Schultz*